Forever

This book belongs to:

.........................

.........................

An Hachette UK Company
www.hachette.co.uk

First published in France in 2014 by Dessain et Tolra

This edition published in Great Britain in 2015 by
Hamlyn, a division of Octopus Publishing Group Ltd
Carmelite House
50 Victoria Embankment
London EC4Y 0DZ
www.octopusbooksusa.com

Distributed in the US by Hachette Book Group
1290 Avenue of the Americas, 4th and 5th Floors, New York, NY 10020

Distributed in Canada by Canadian Manda Group
664 Annette St., Toronto, Ontario, Canada M6S 2C8

ISBN 978-0-600-63289-4

Printed and bound in China

10 9 8 7 6 5 4 3 2 1

Publishing directors: Isabelle Jeuge-Maynart, Ghislaine Stora
Editorial direction: Colette Hanicotte
Cover: Claire Morel Fatio, Abigail Read
Layout: Claire Morel Fatio
Senior production manager: Katherine Hockley

Coloring for mindfulness

Tattoos

*50 designs to
help you de-stress*

hamlyn

Forget everyday cares and worries!

Relax with the practical and artistic tradition of tattooing which stretches back into pre-history and forms part of many religious and magic rituals. Today tattoos are a fashion phenomenon, appreciated for their refined design and visual impact. They come in so many different styles—from tribal to Asian and Chicano—with motifs that have many different meanings.

In this book you'll find 50 imaginative designs to color in with vivid shades. Just choose one that appeals to you instinctively, at random, and begin. There are no rules: use whatever medium you like—felt tips, pencils, gouache, pastels—and whatever colors you like from the selection available. Concentrate on all the little details.

Gradually a feeling of calm will take over and you will be completely absorbed in what you are doing and the colors filling up the blank shapes. It's a great way to reboot a brain too occupied with the demands of smartphones and tablets.

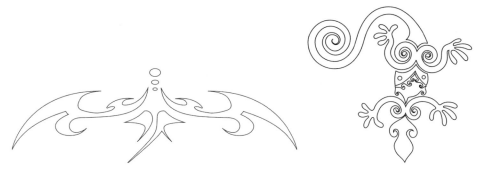

There are also some blank spaces to fill and some designs which have been started with dotted lines for you to continue, guided by just your imagination and chance.

Finally, to help with concentration and meditation, cut out the designs that inspire you the most. Contemplate them in a calm environment, allowing your thoughts to roam free.

Just 5 to 10 minutes of coloring a day will help you to relax and find inner peace.

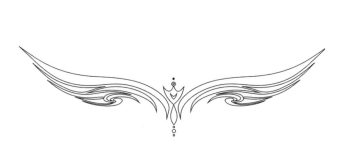

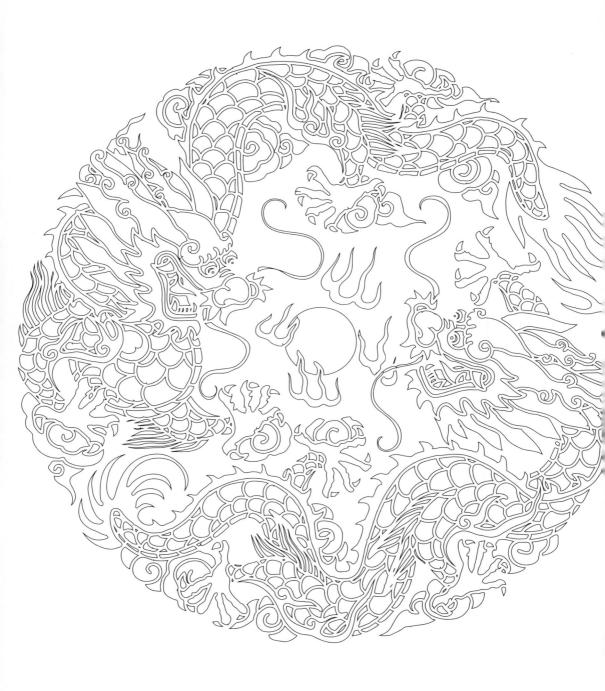

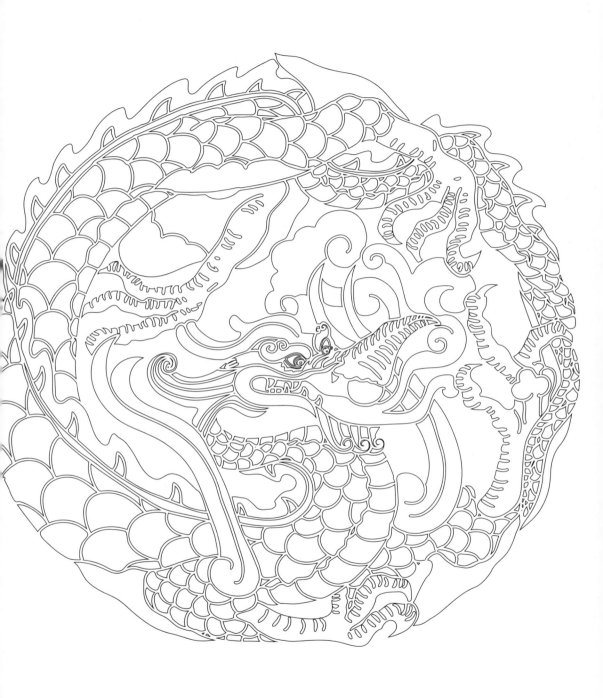

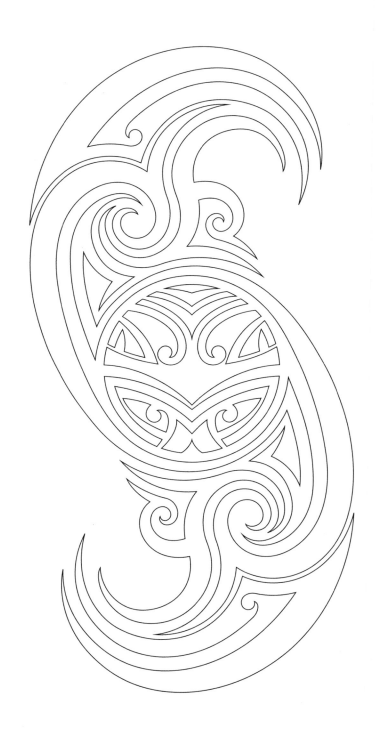

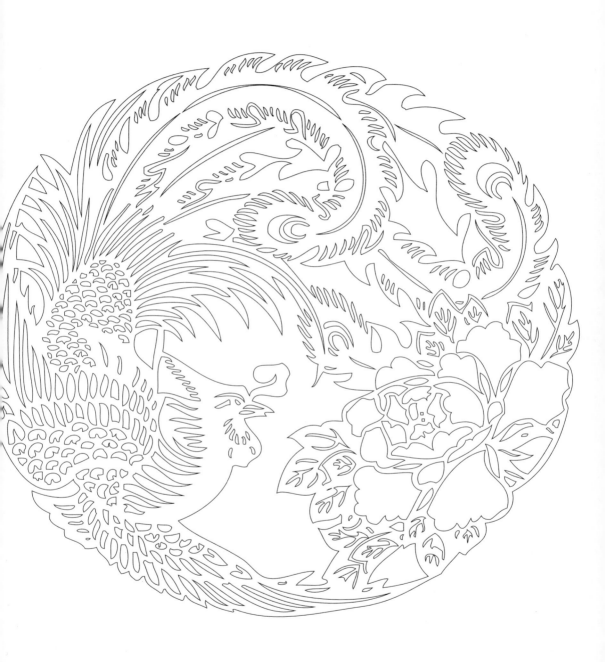

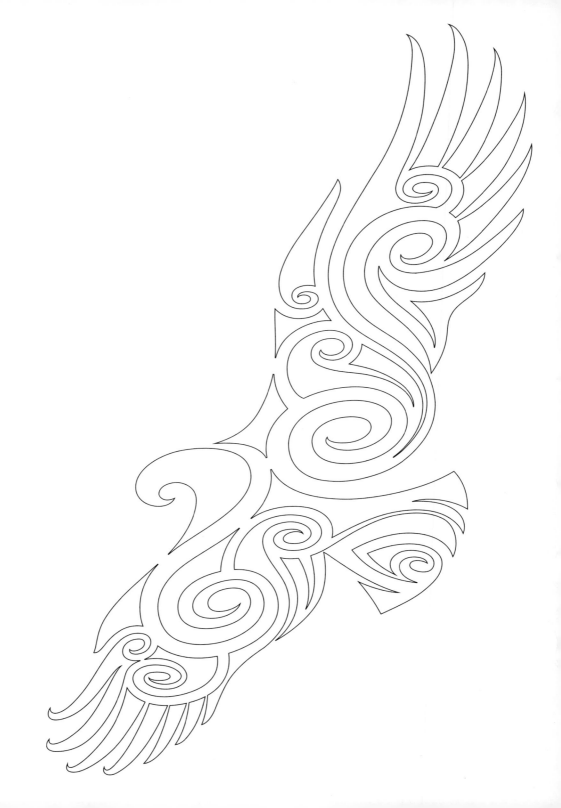

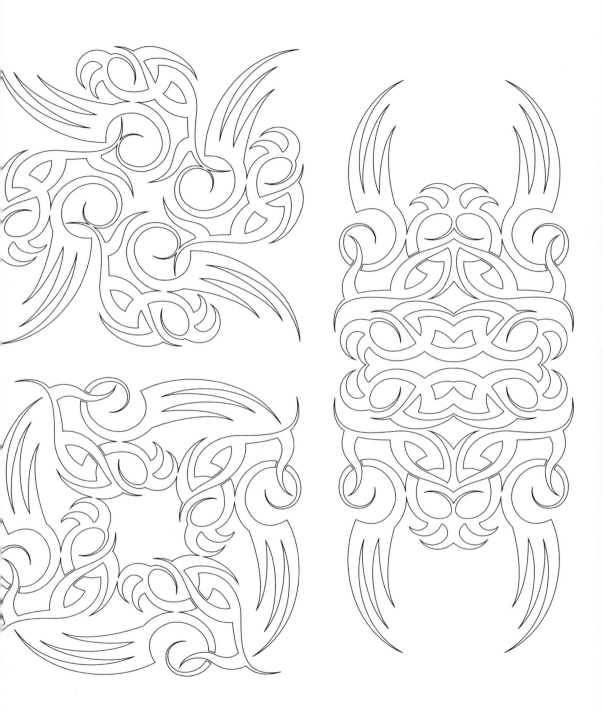

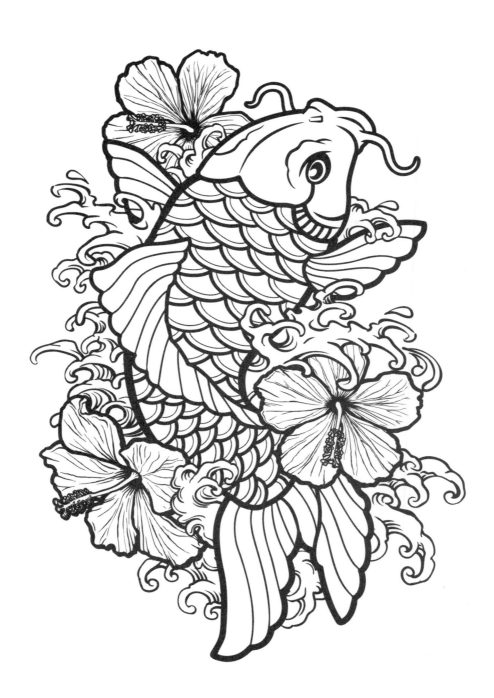

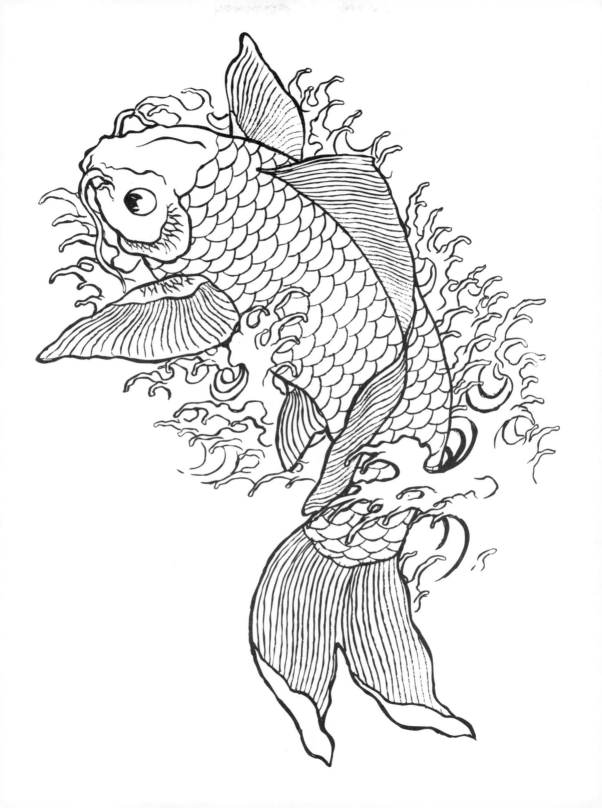

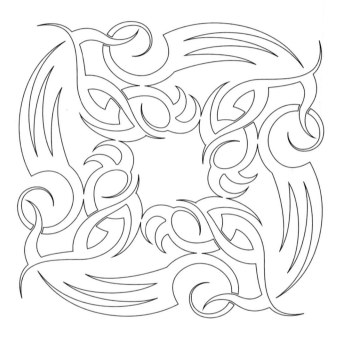

Complete the design with abstract curves.

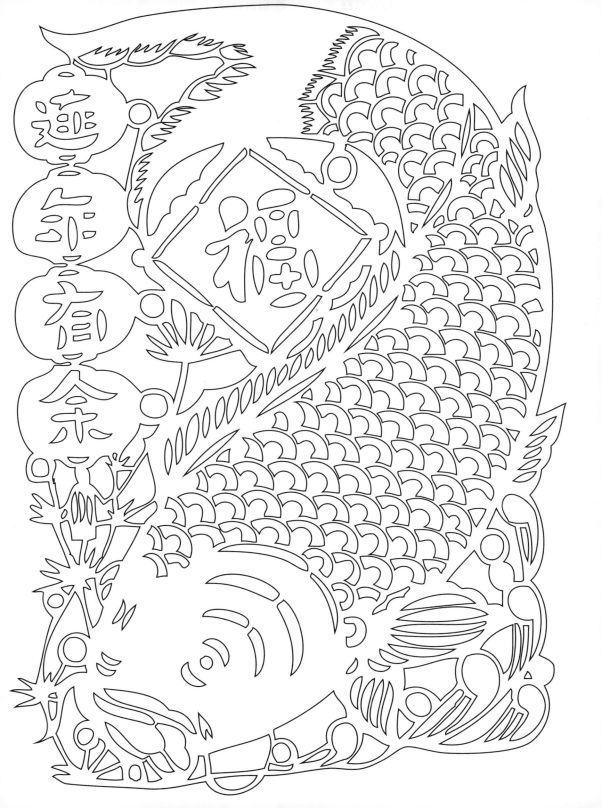

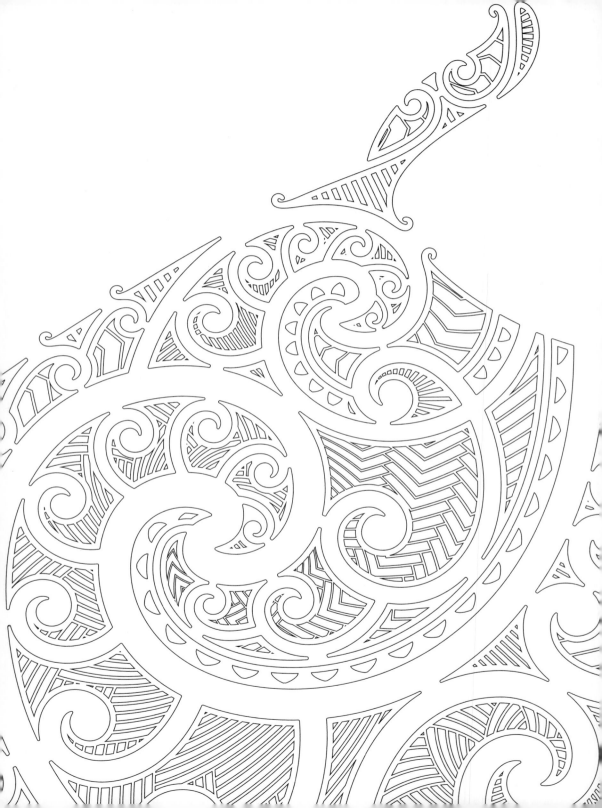

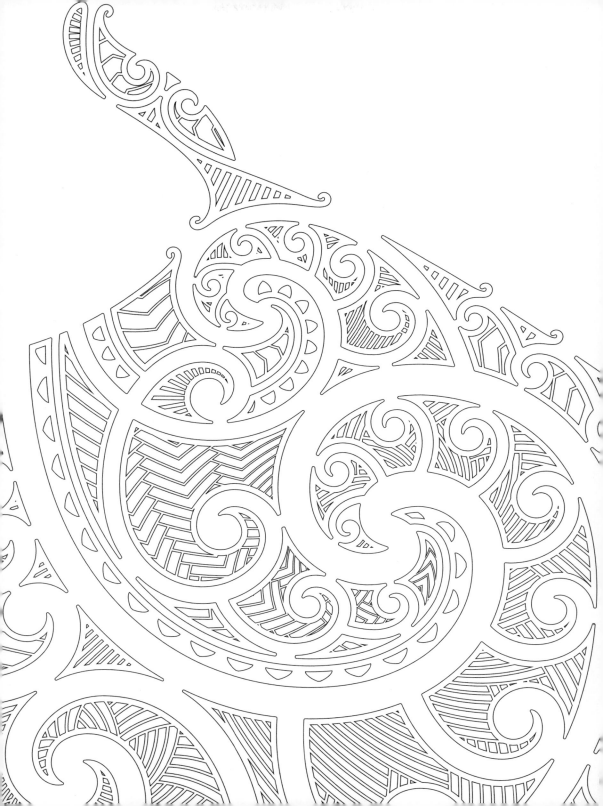

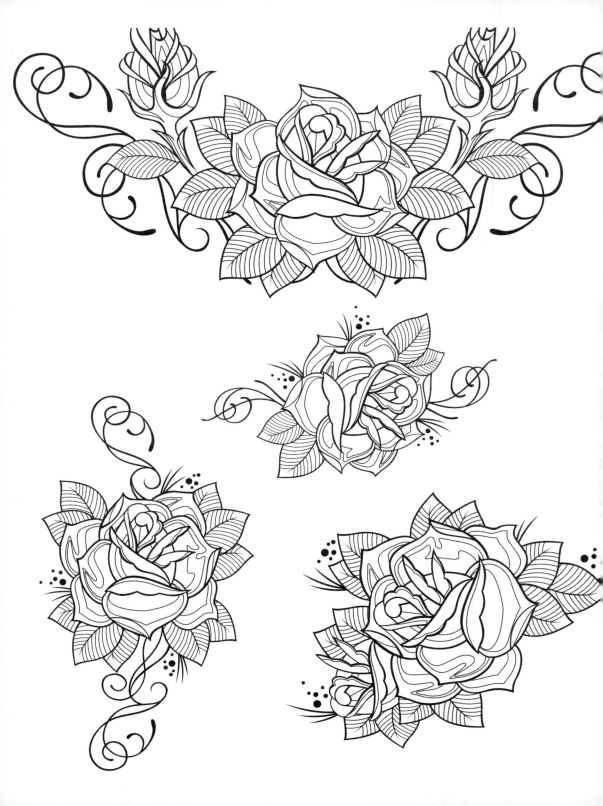

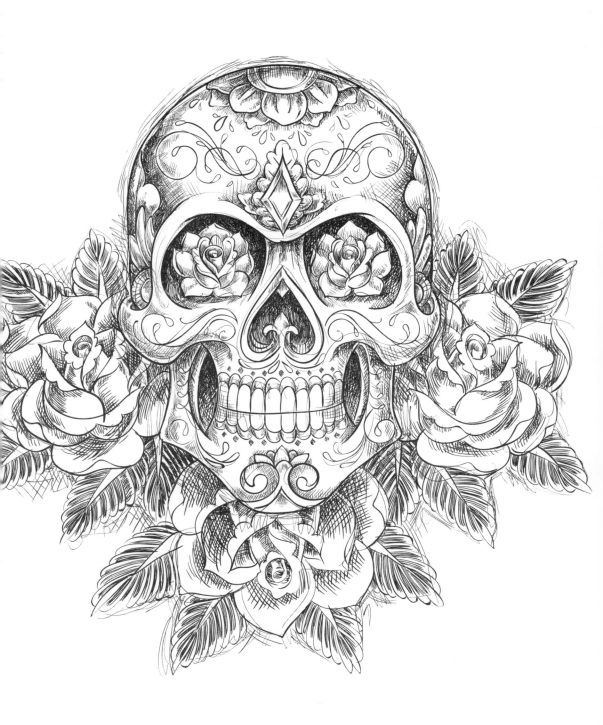

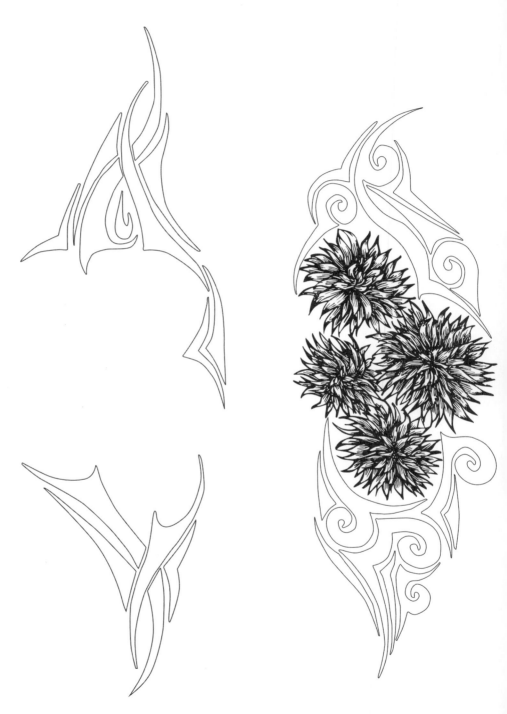

Complete with the flowers of your choice.

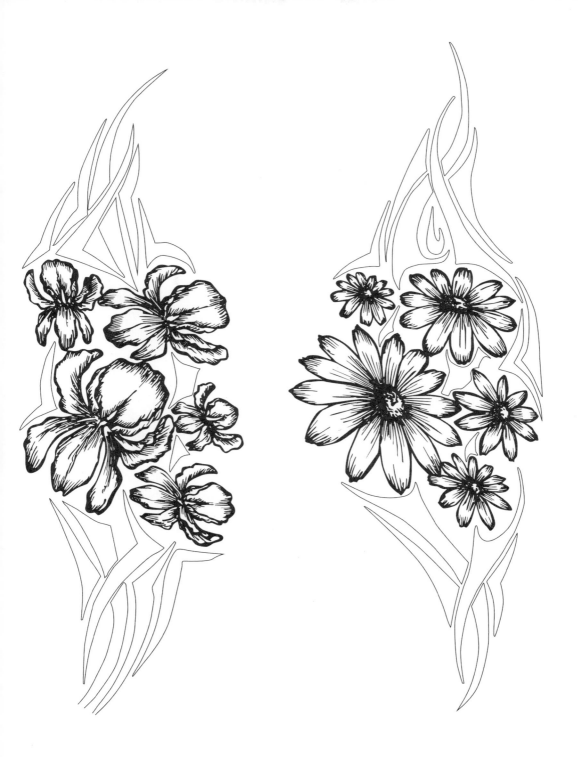

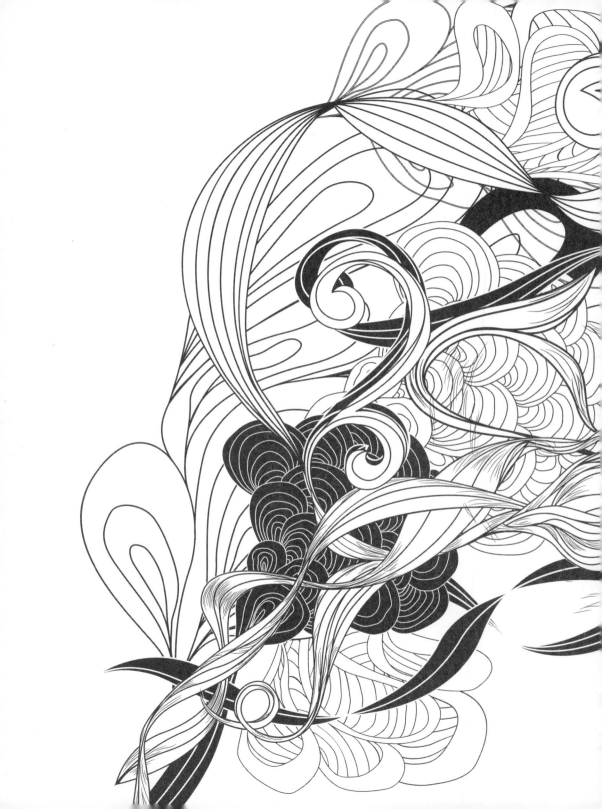

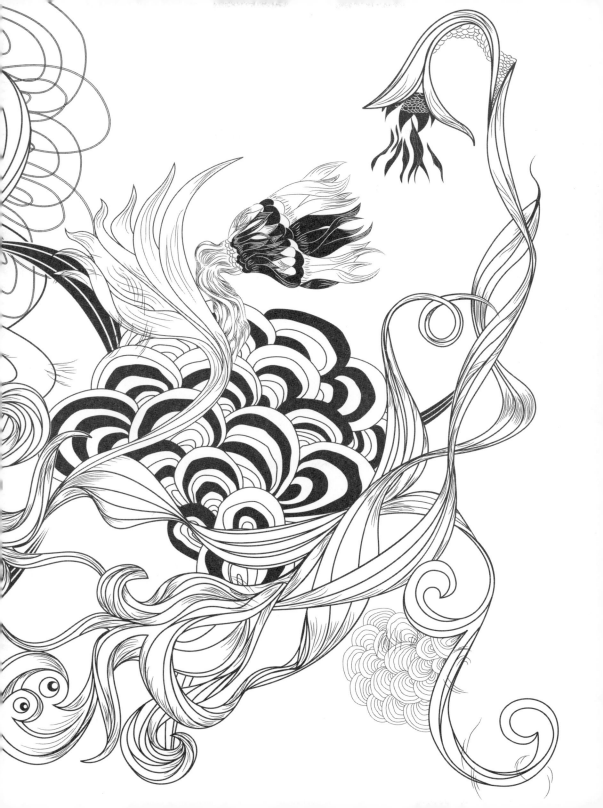

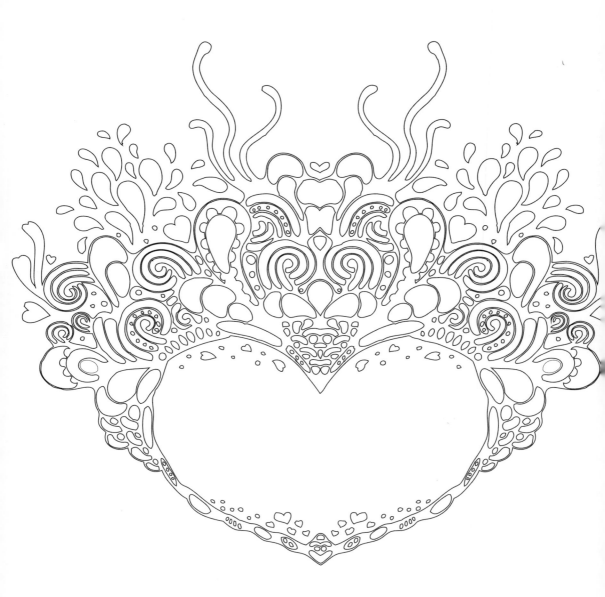

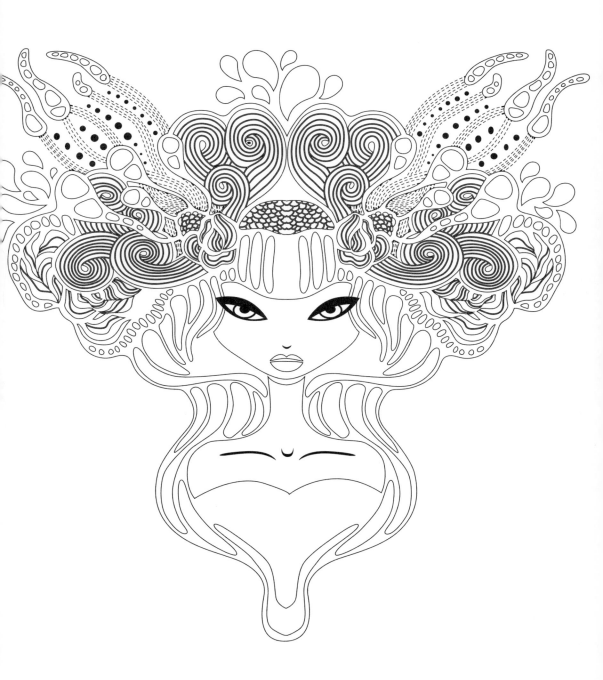

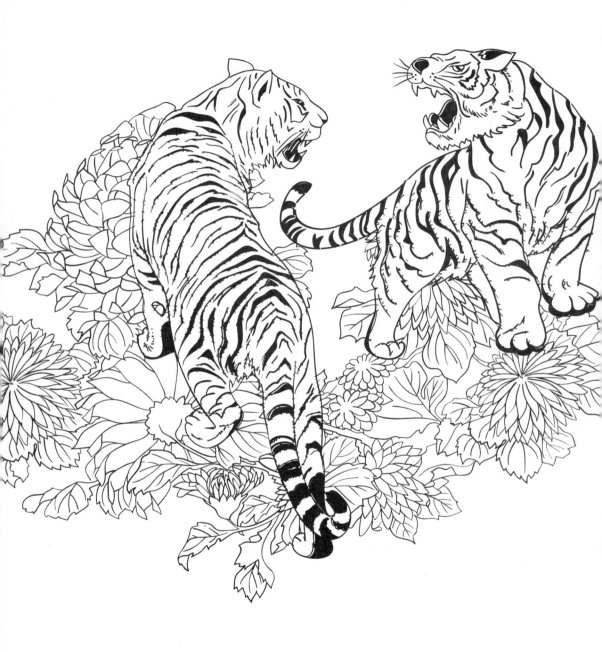

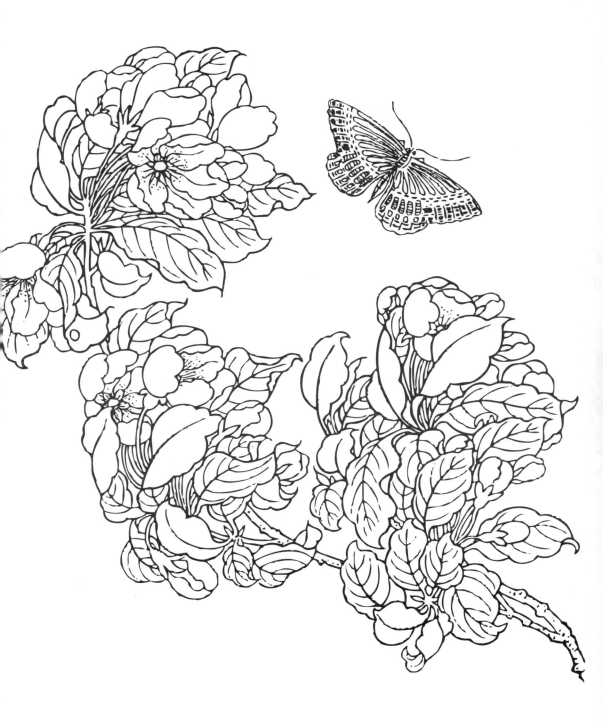

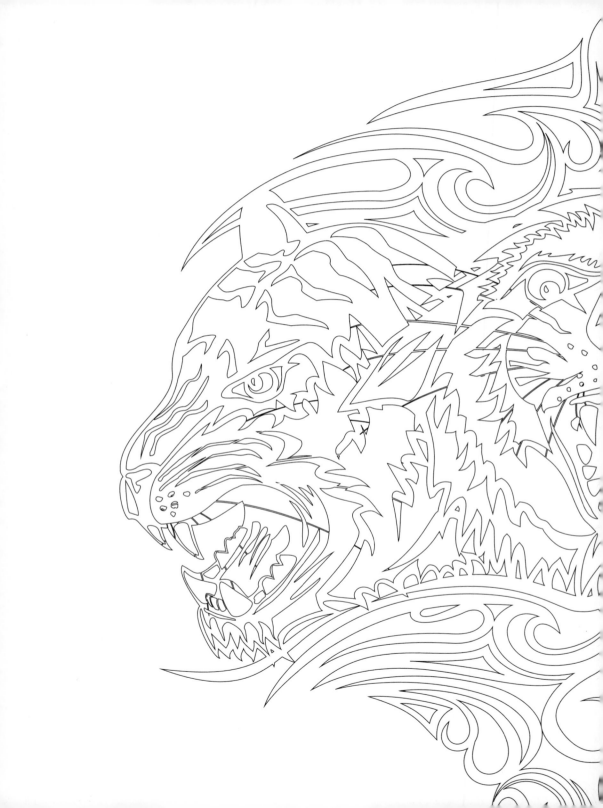

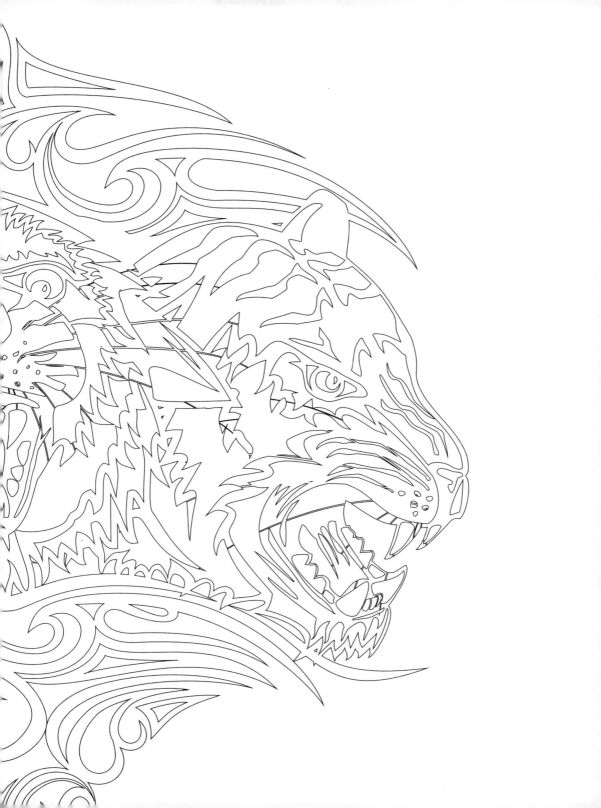

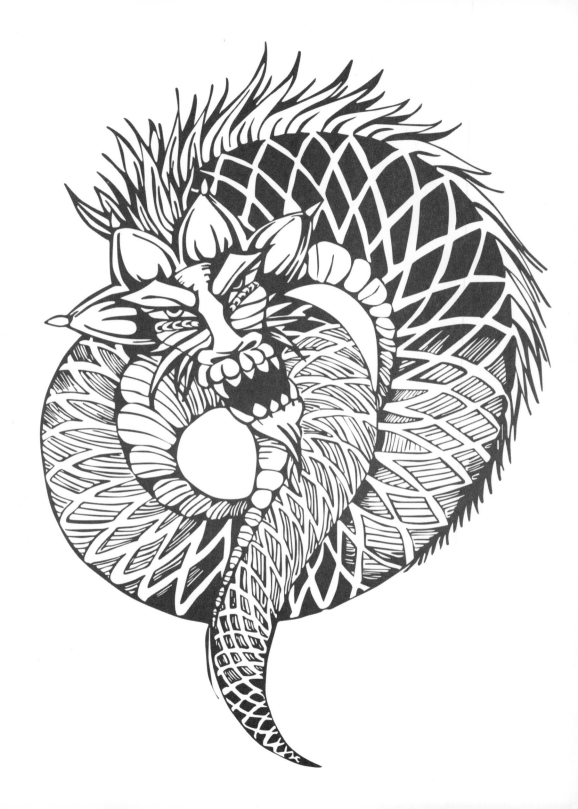

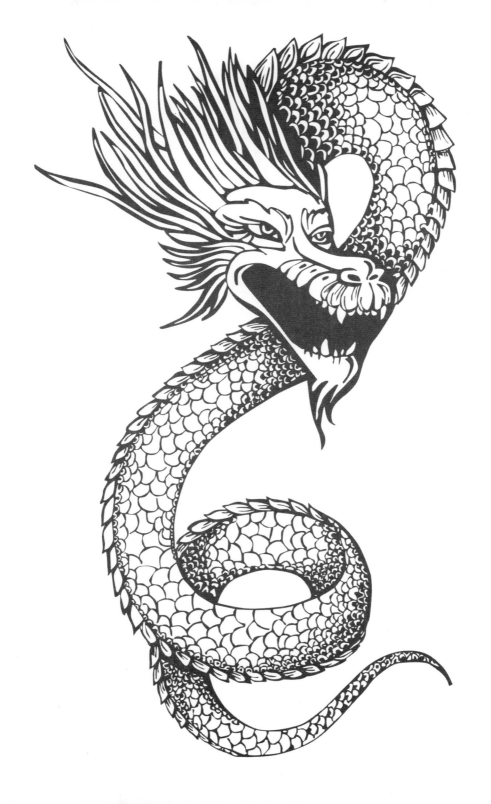

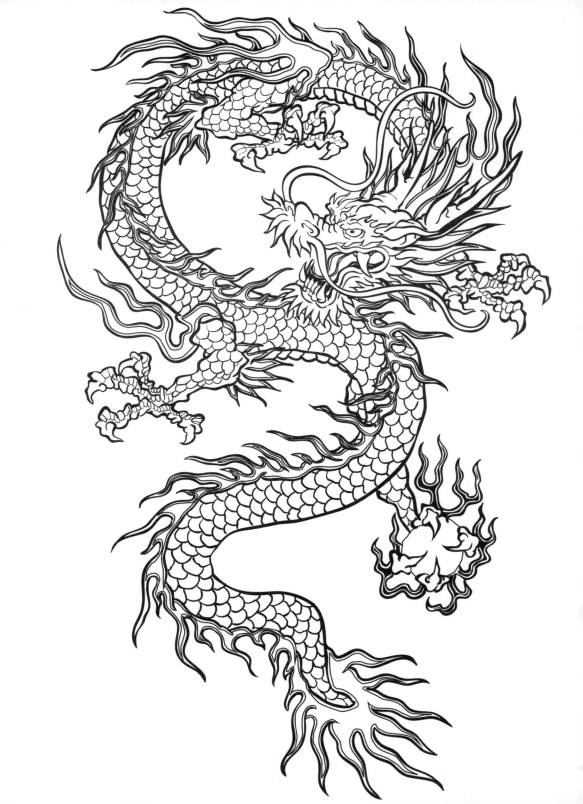

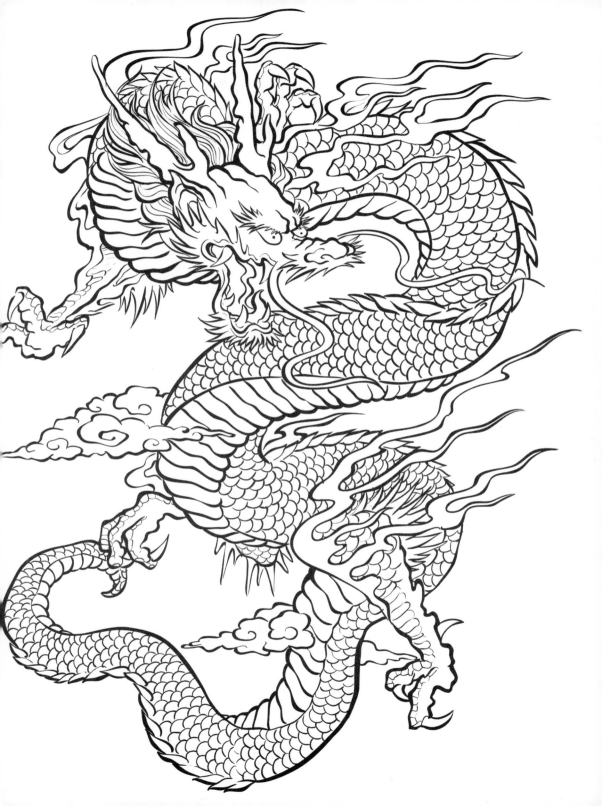

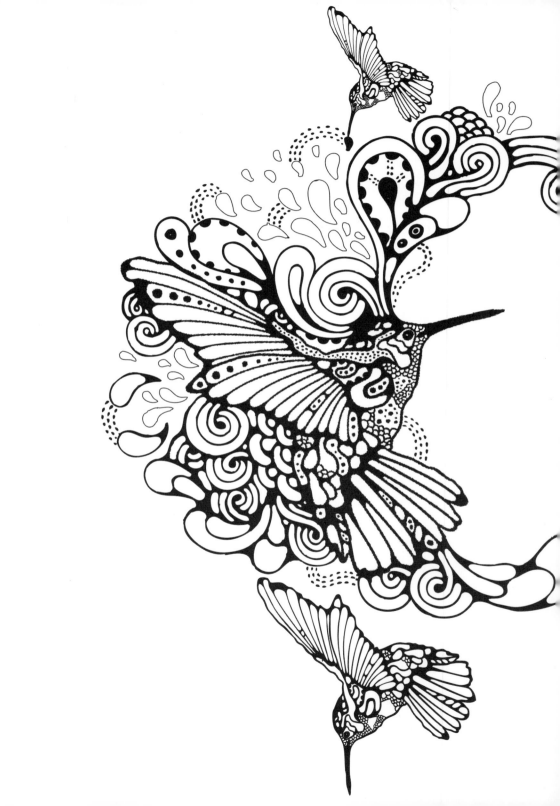

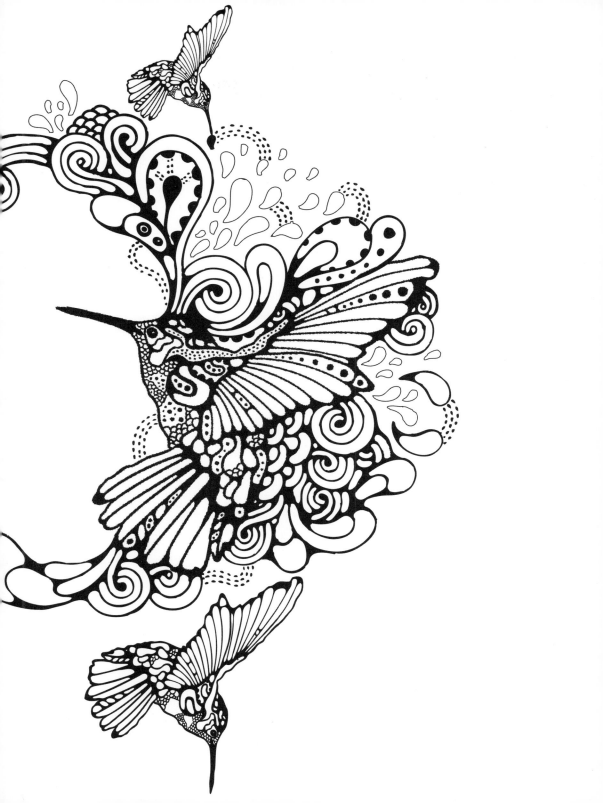

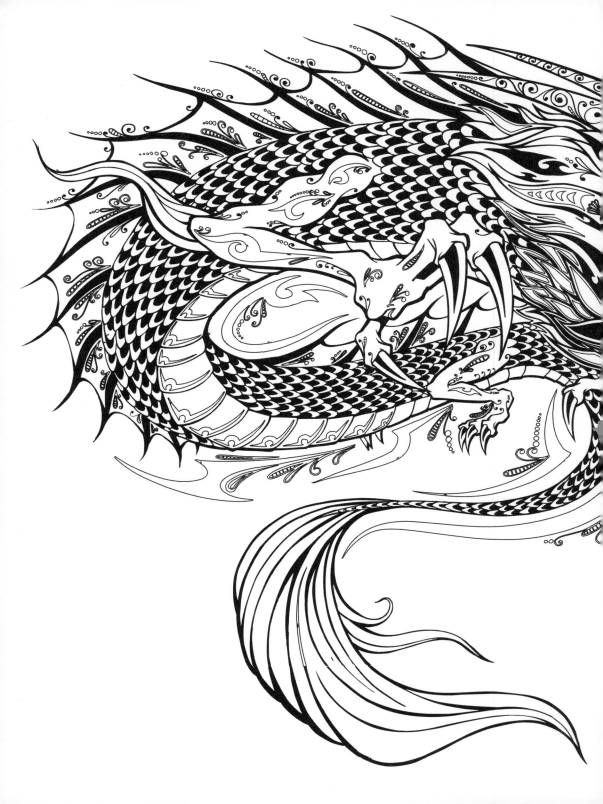

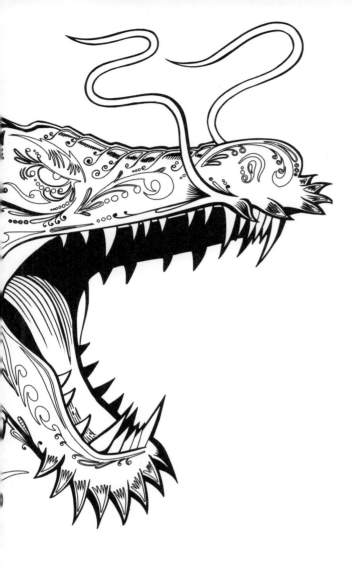

Design and color in the breath of the oriental dragon, a creative force of nature.

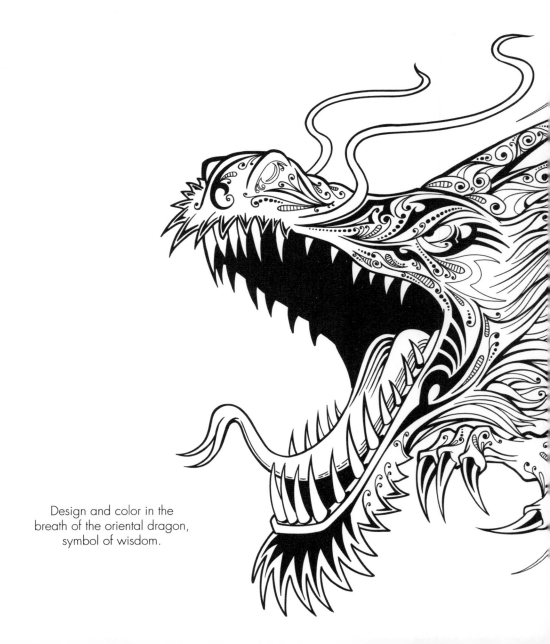

Design and color in the
breath of the oriental dragon,
symbol of wisdom.

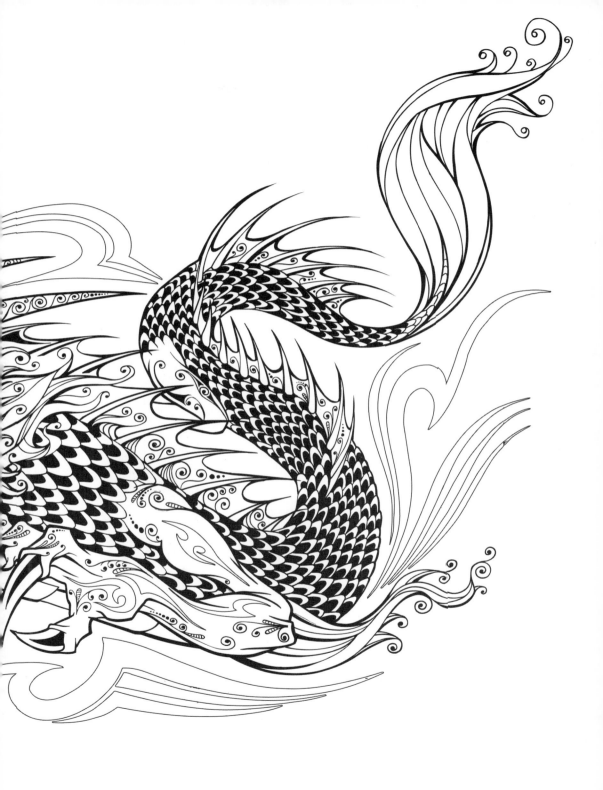

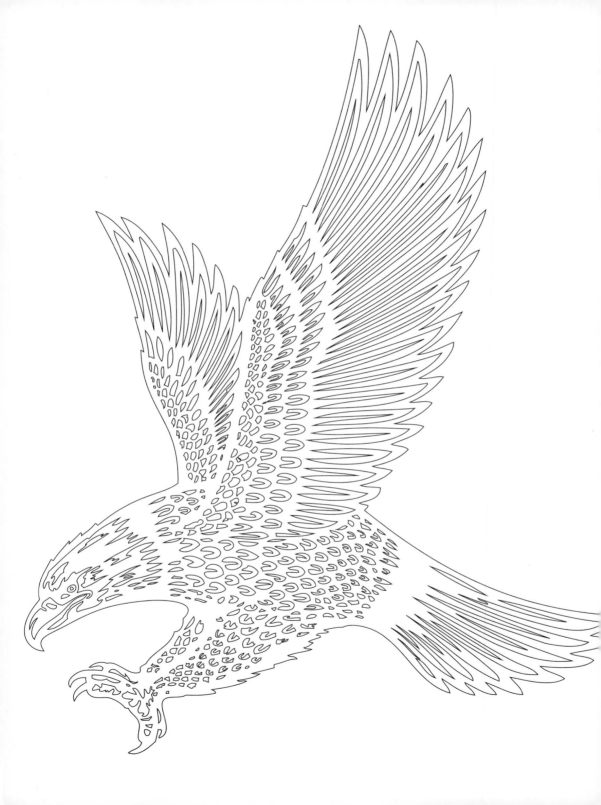

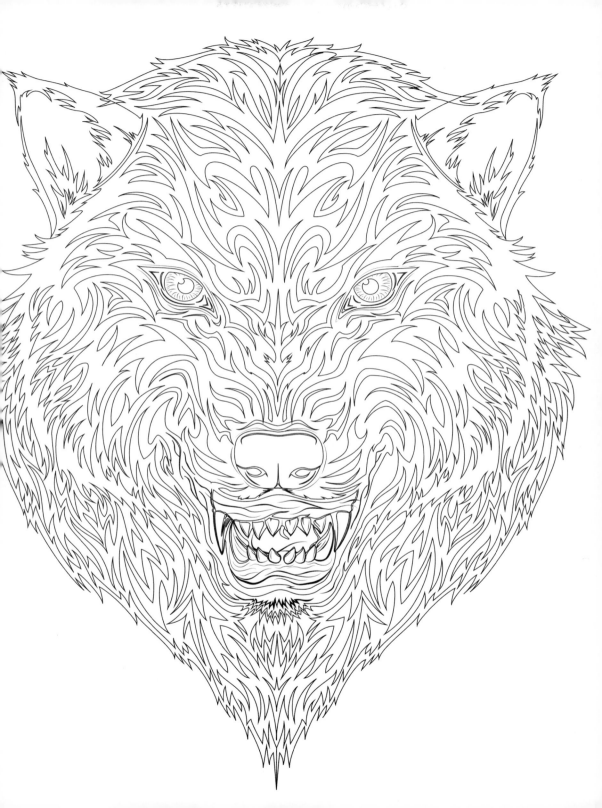

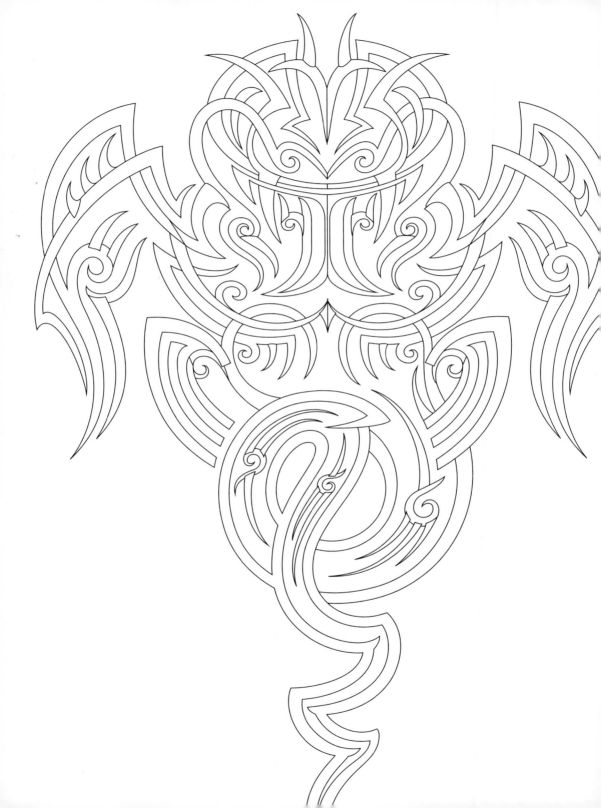

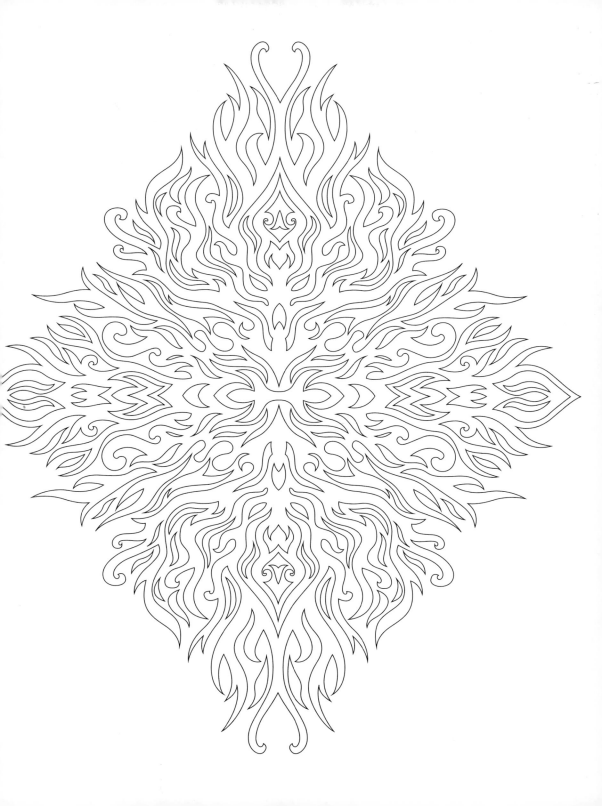

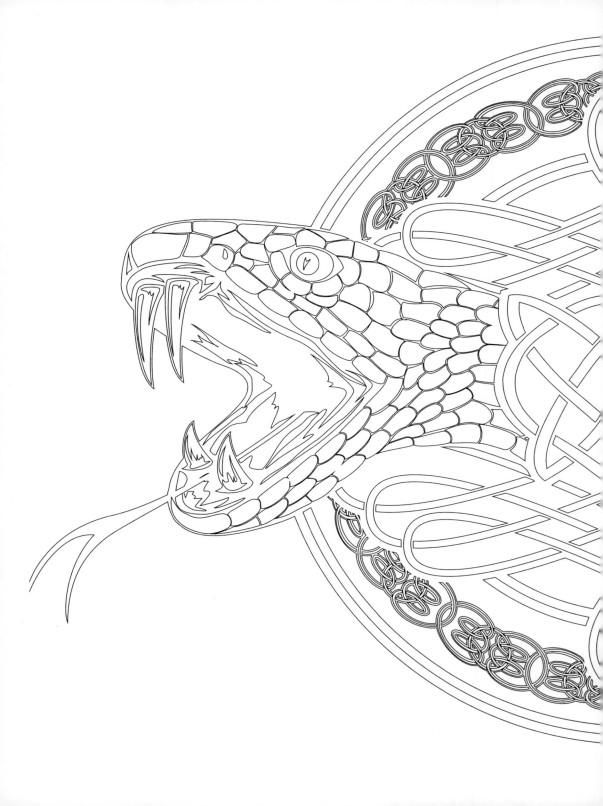

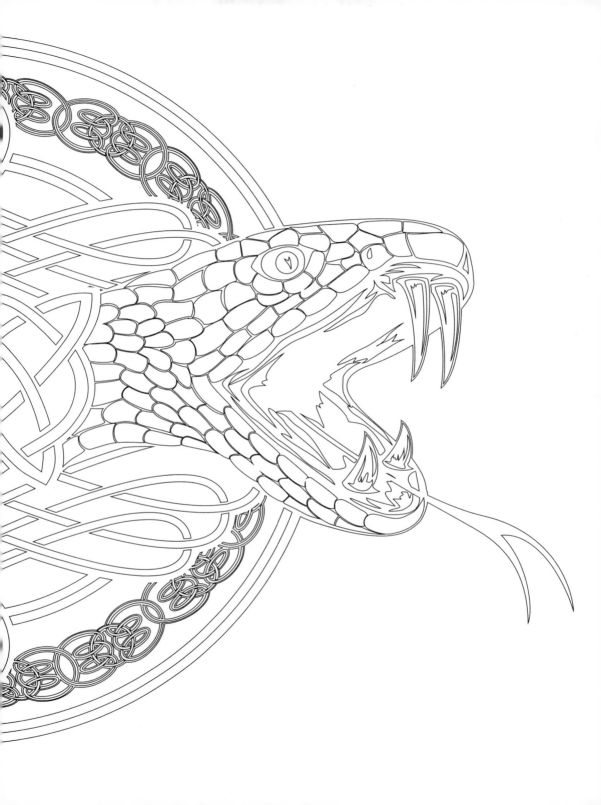

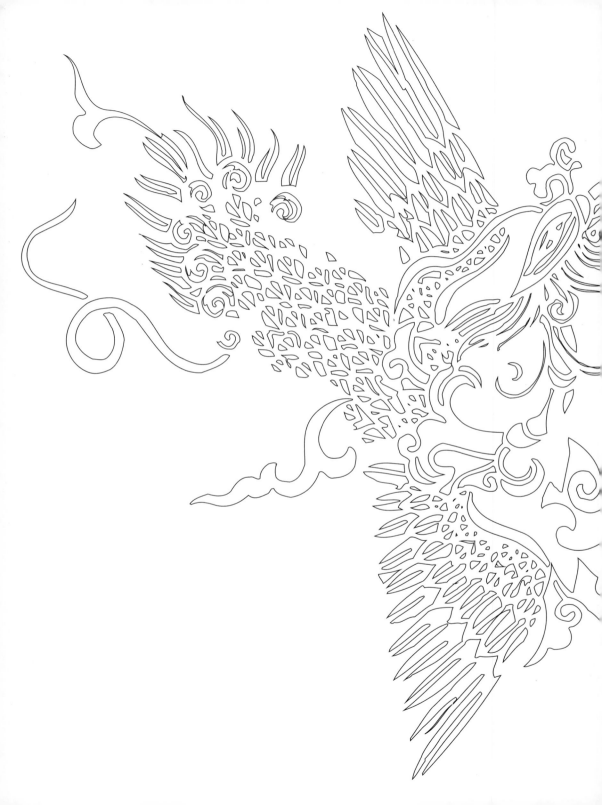

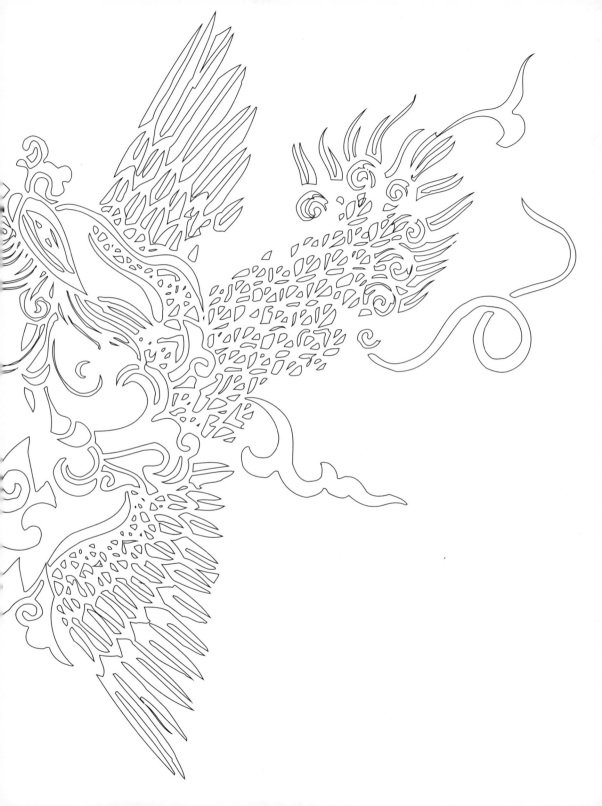

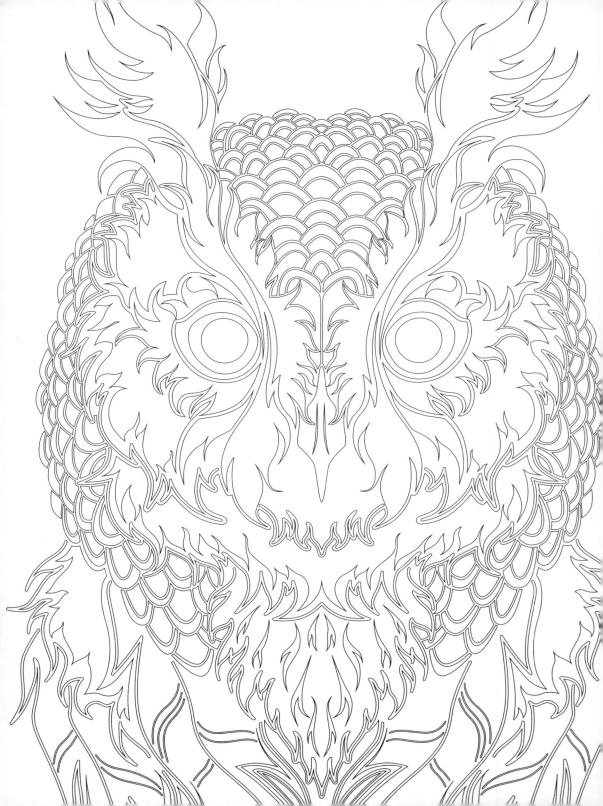

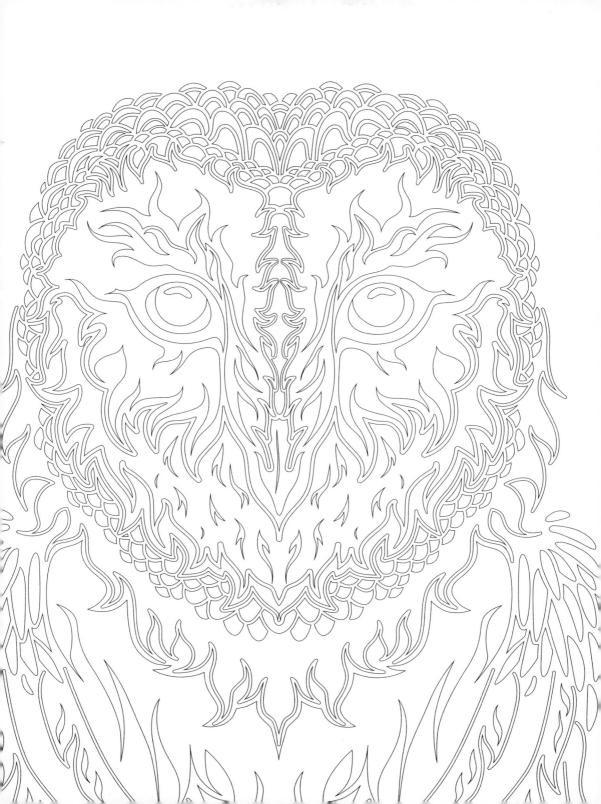

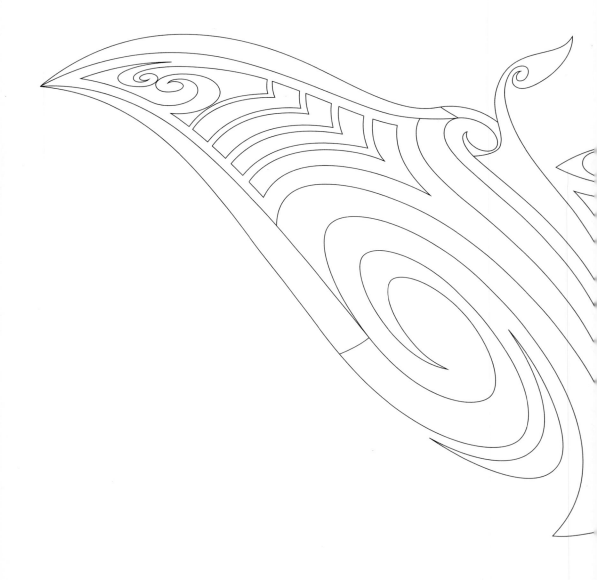

Complete and design a supernatural nocturnal bird.

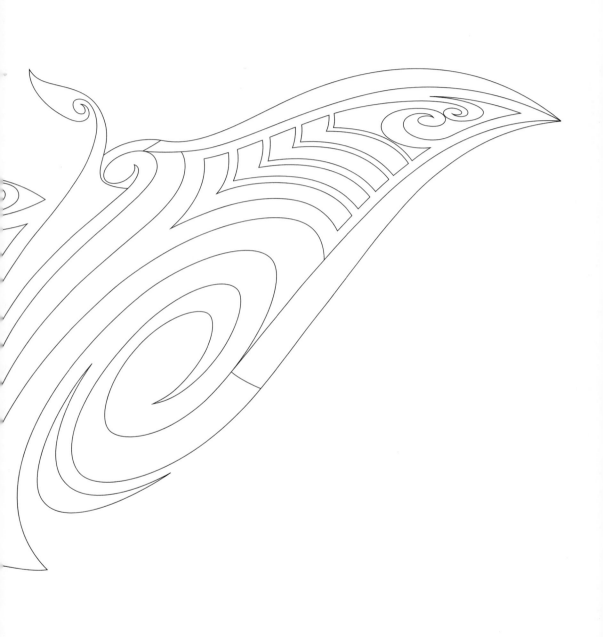

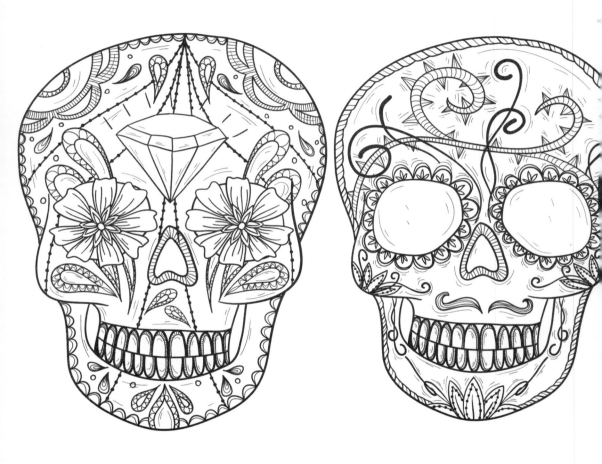

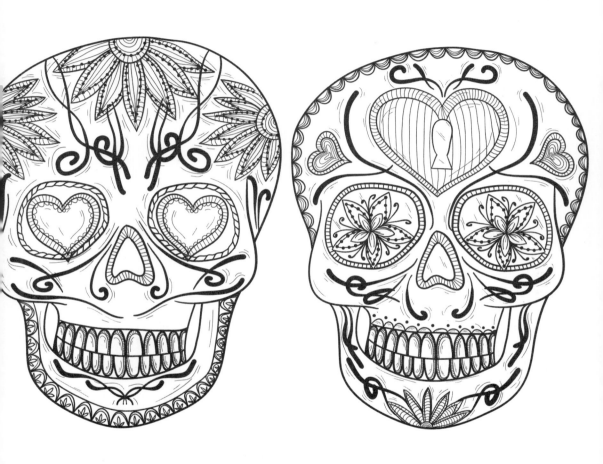

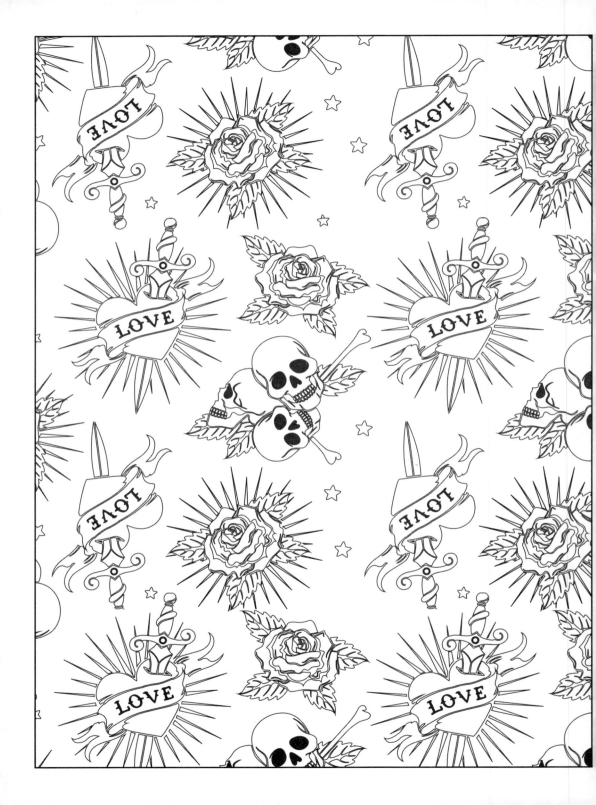

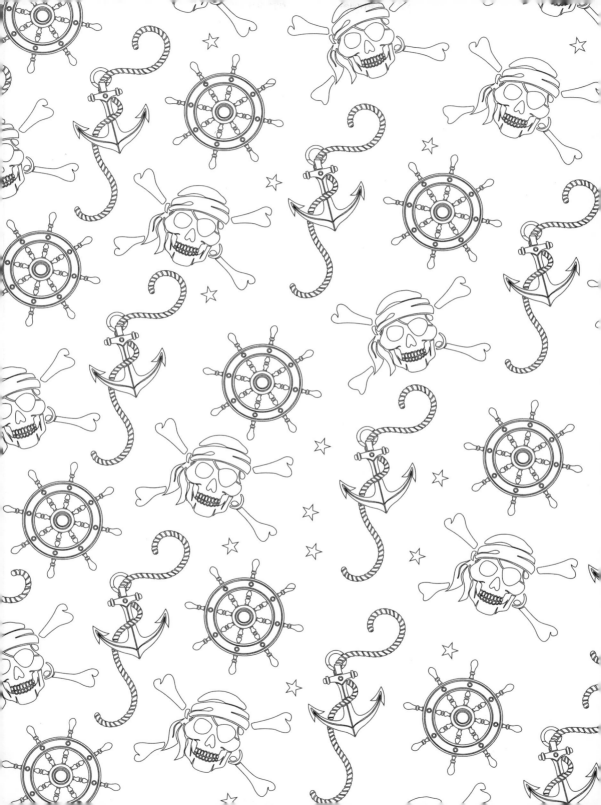

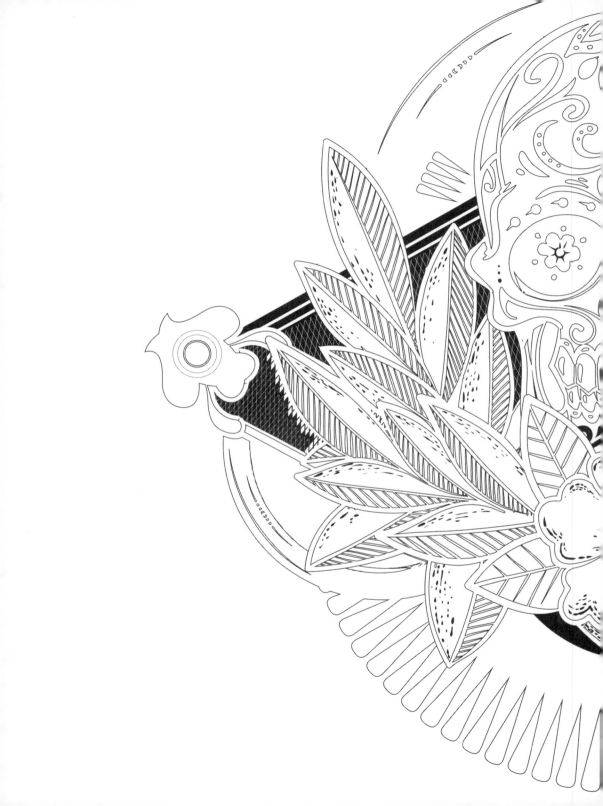

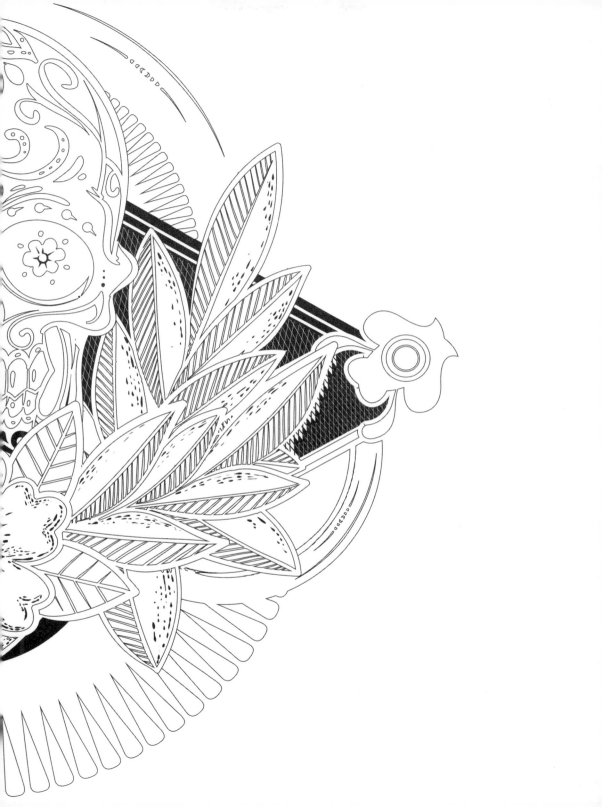

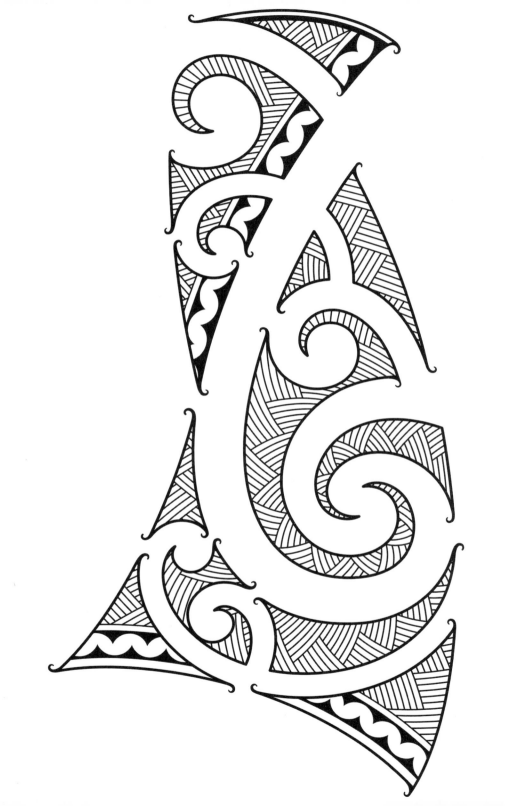

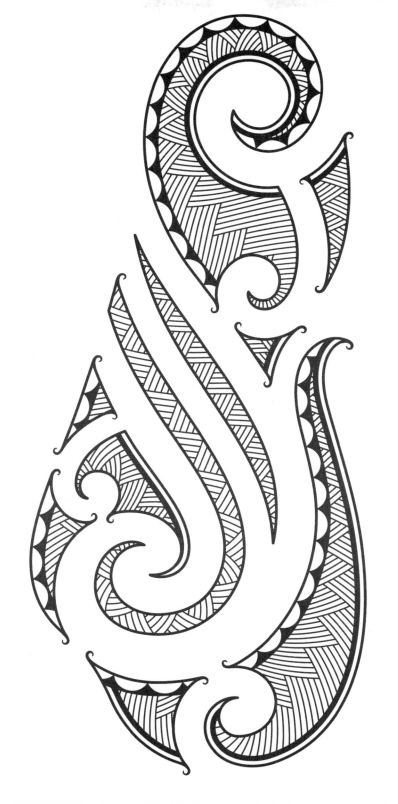

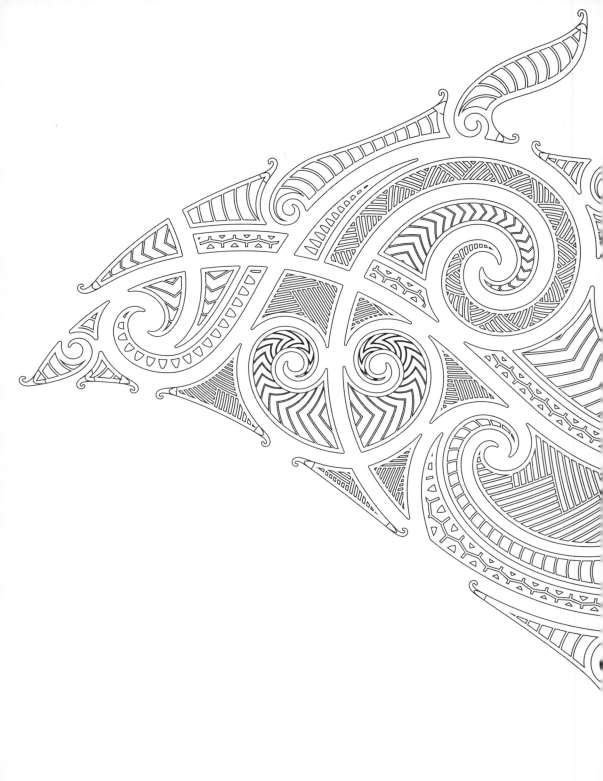

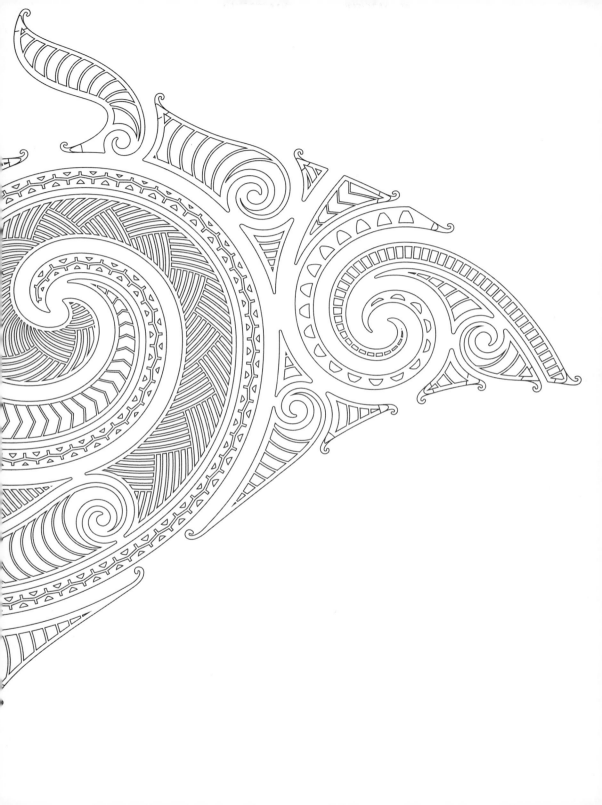

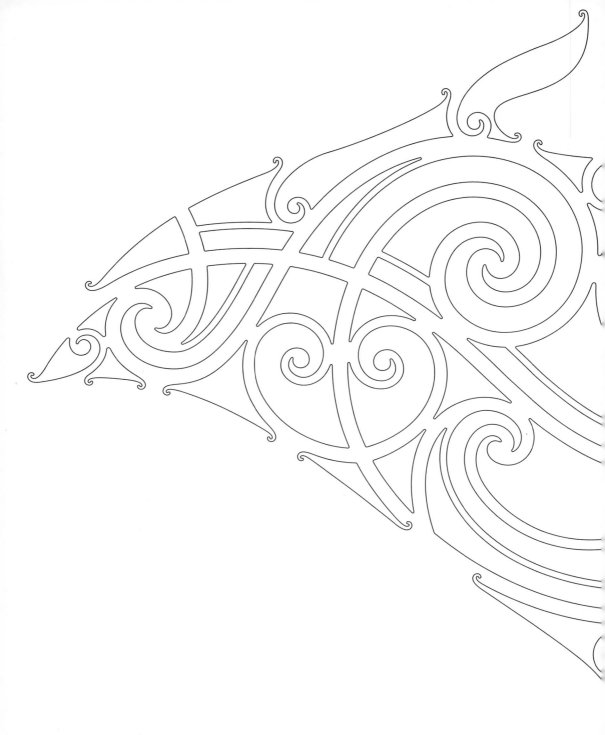

Complete and design geometric motifs.